# How to Draw
# Manga Heroes

## In simple steps

T0020658

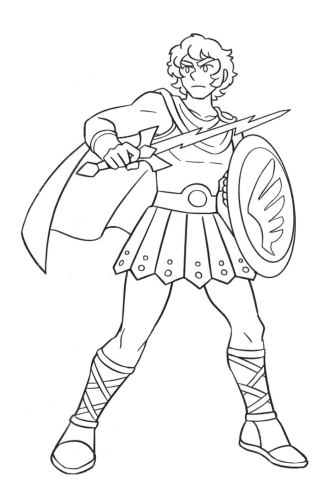

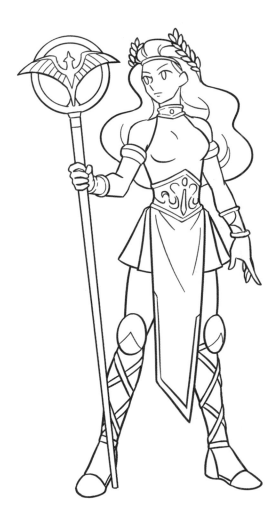

First published in 2023

Search Press Limited
Wellwood, North Farm Road,
Tunbridge Wells, Kent TN2 3DR

Text and illustrations copyright © Yishan Li, 2023

Design copyright © Search Press Ltd. 2023

All rights reserved. No part of this book, text, photographs or illustrations may be reproduced or transmitted in any form or by any means by print, photoprint, microfilm, microfiche, photocopier, video, internet or in any way known or as yet unknown, or stored in a retrieval system, without written permission obtained beforehand from Search Press. Printed in China.

ISBN: 978-1-80092-116-0
ebook ISBN: 978-1-80093-103-9

Readers are permitted to reproduce any of the drawings or paintings in this book for their personal use, or for the purposes of selling for charity, free of charge and without the prior permission of the Publishers. Any use of the drawings or paintings for commercial purposes is not permitted without the prior permission of the Publishers.

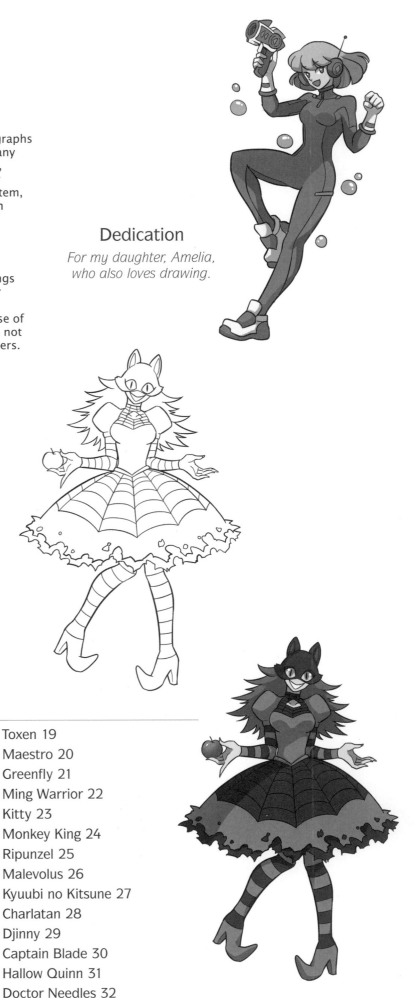

## Dedication

*For my daughter, Amelia,
who also loves drawing.*

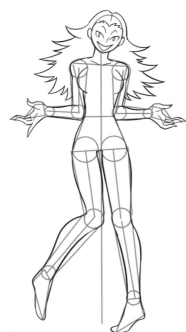

## Illustrations

# How to Draw
# Manga Heroes

## In simple steps
## Yishan Li

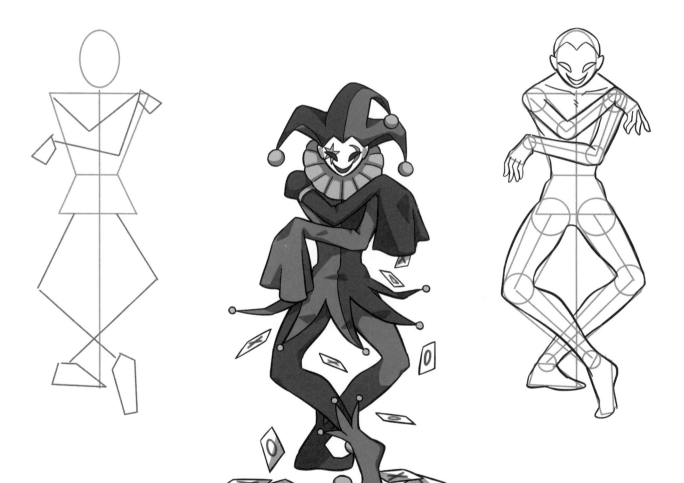

Search Press

# Introduction

In this book I will show you how to draw twenty male and female heroes and eight villains. Every project has eight steps to guide you through the drawing process: each starts with very simple shapes, then gradually further shapes and details are added. I use different colours to indicate the new strokes added in each step. The first or previous step is always shown in blue, with new lines added in pink. After that, black lines are used to draw the image itself, then the final image is fully coloured to show you the complete picture.

Of course, you don't need to use blue and pink lines: when you start to draw, all you need is paper, a pencil and an eraser. I prefer normal copying paper to special art paper because it's cheaper and easy to draw on. You can choose any soft graphite pencil, preferably a 2B. Your eraser can just be the one you normally use at home or school.

When drawing the initial shapes, start with very light strokes, then add more details using slightly more solid lines. This way you can see your final image clearly rather than burying it with messy lines.

Once you are more confident with your pencil drawings, you can start to add ink and colour. For this you need an ink pen and whatever colouring materials you choose. The ink pen can be any black waterproof gel pen. Try it first on a spare piece of paper to make sure it doesn't smudge. This means that you can rub out all the pencil lines with the eraser without smudging the outlines. For colouring, I use water-based dye ink pens, but you may prefer to use watercolour or coloured pencils.

The most important thing I hope you learn from this book is to be creative. But also, I want you to have fun: change the characters' outfits to make your own unique heroes and villains!

*Happy drawing!*

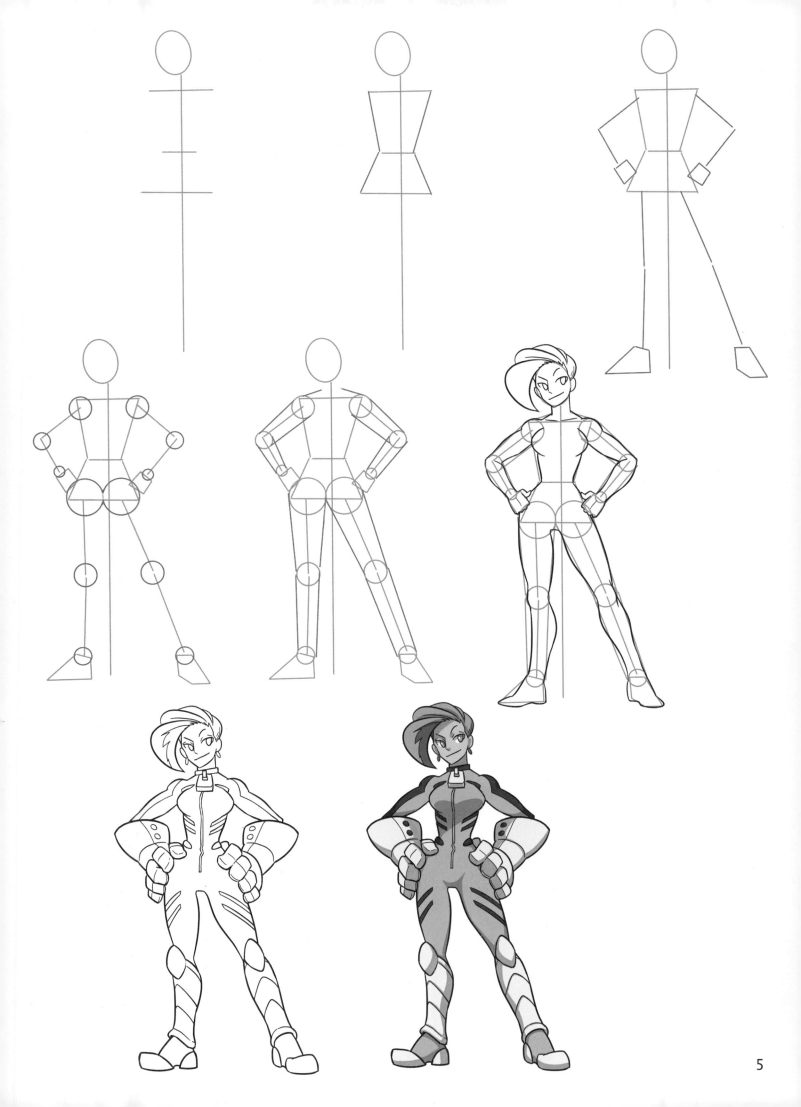

5

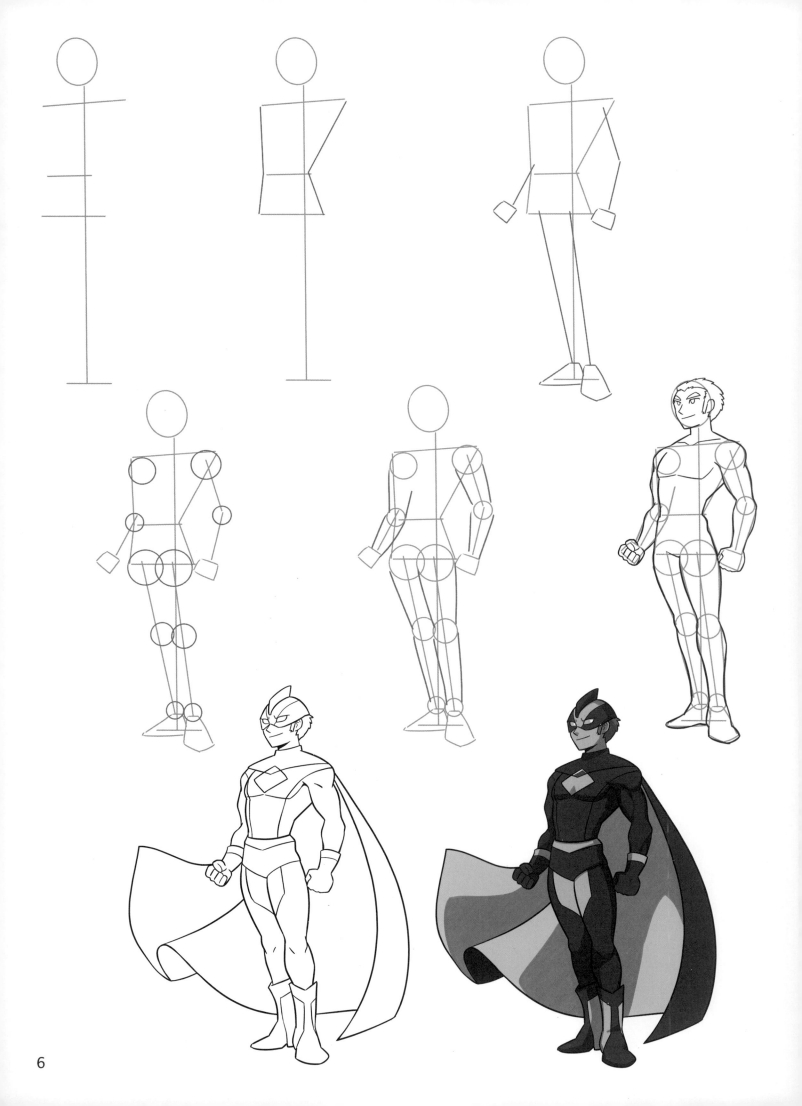

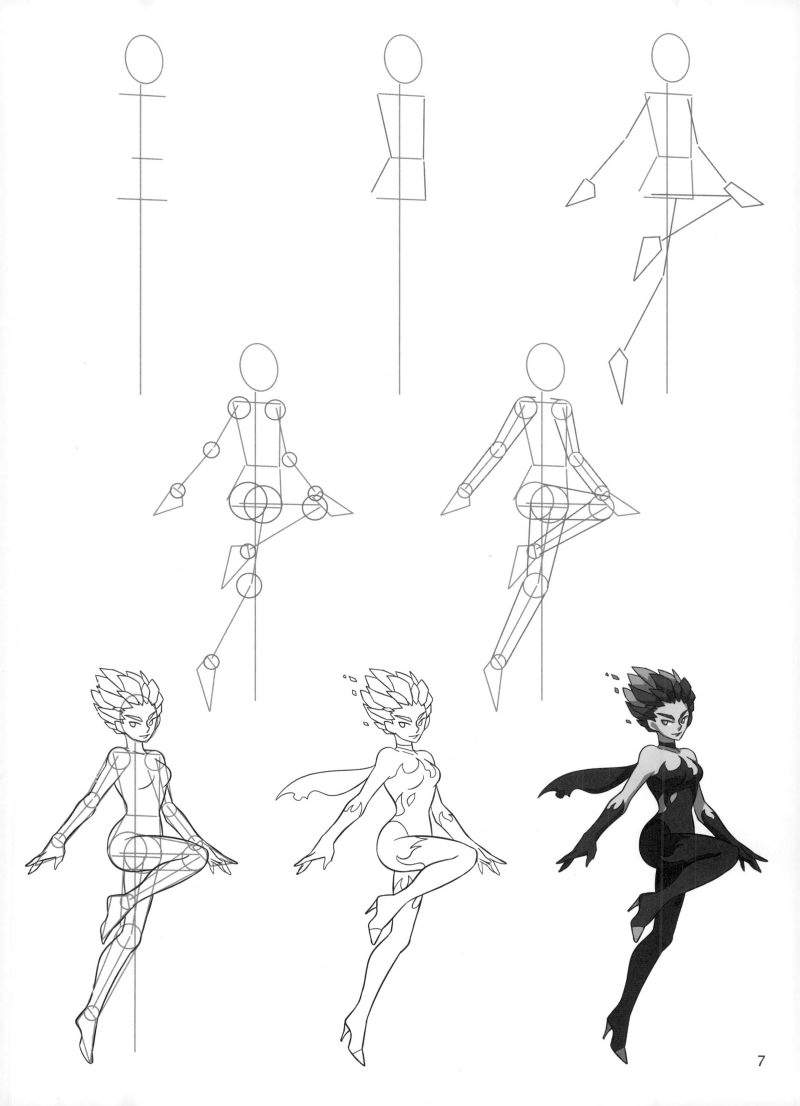

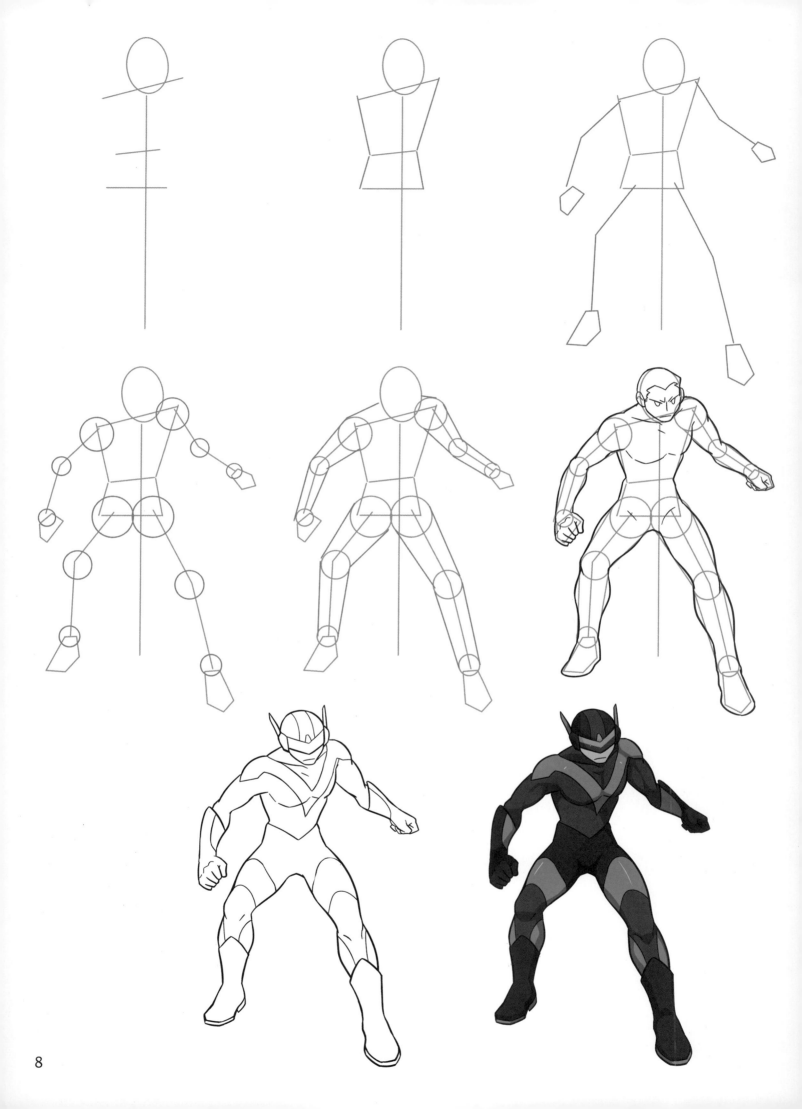

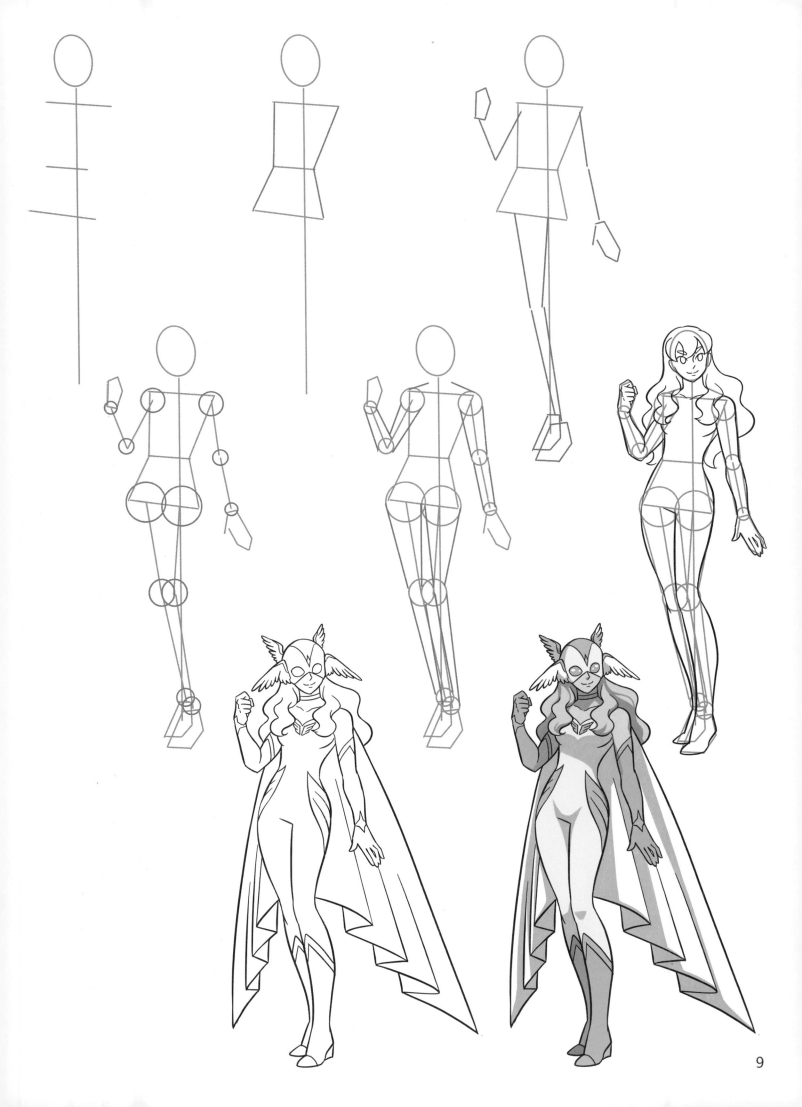

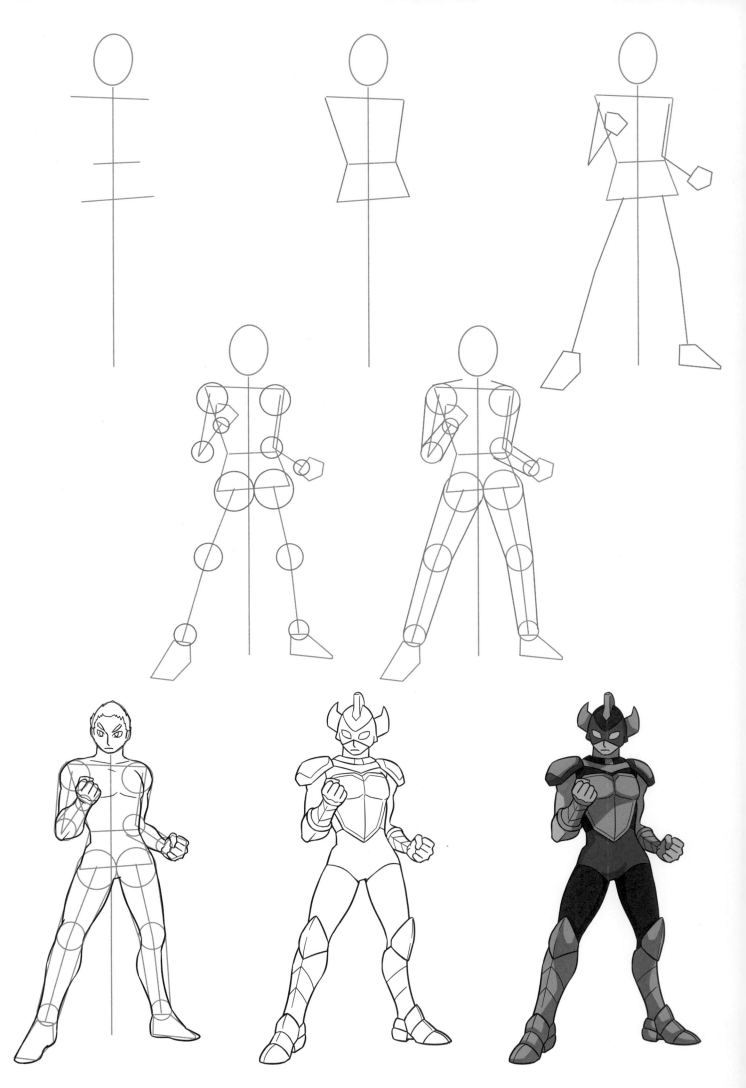

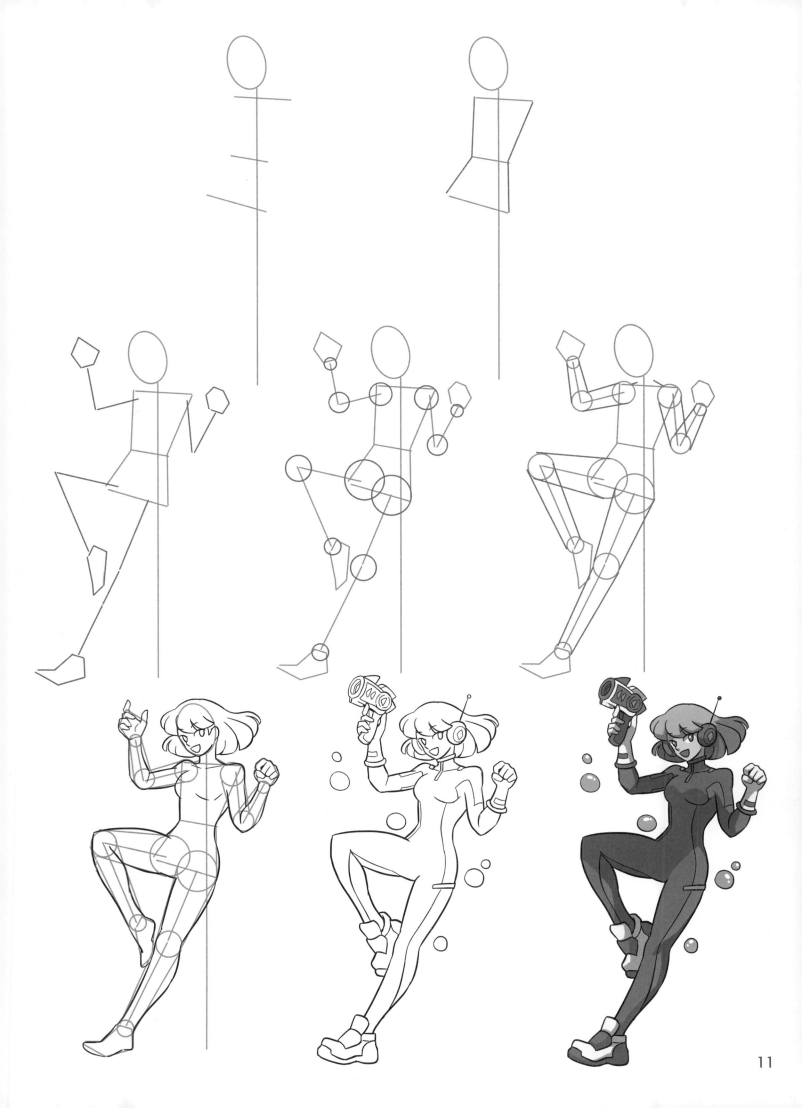

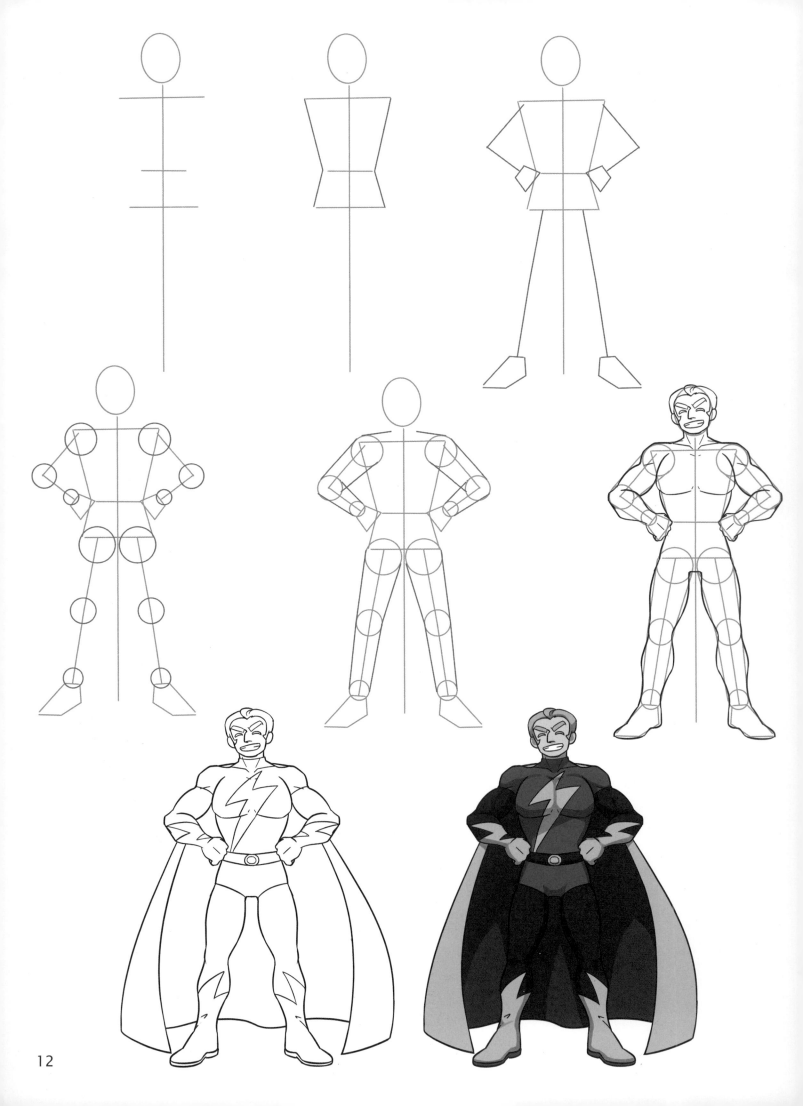

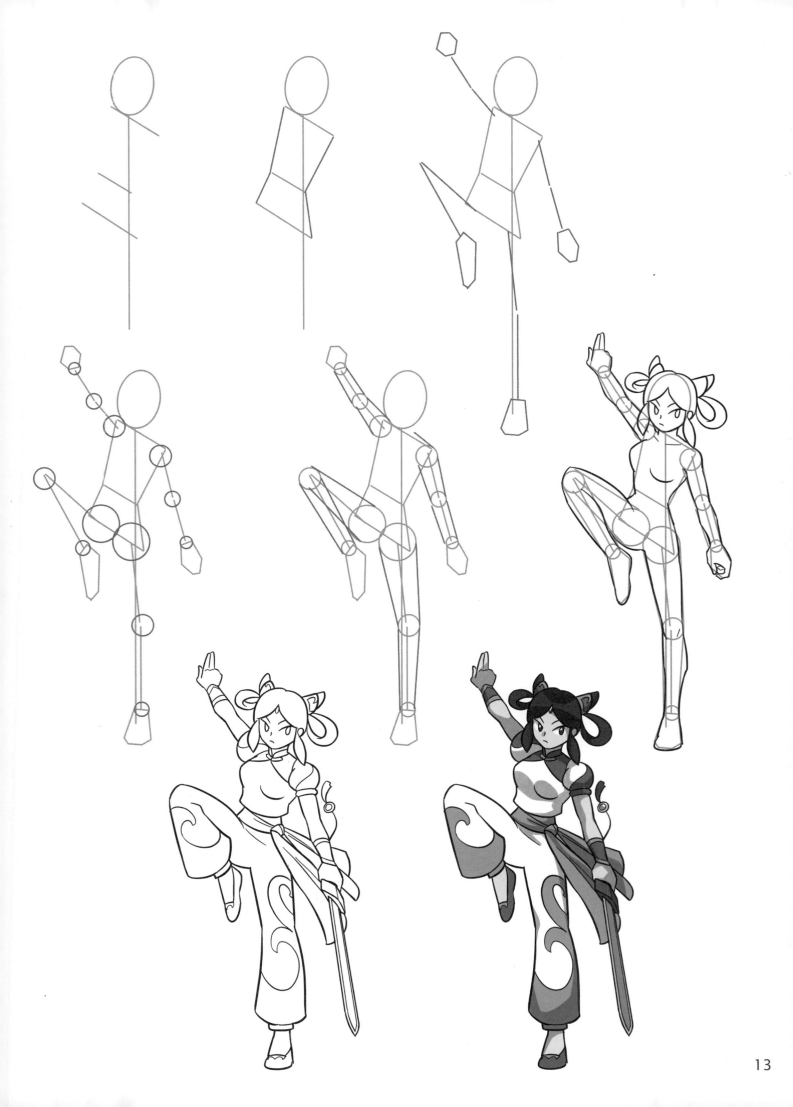

13

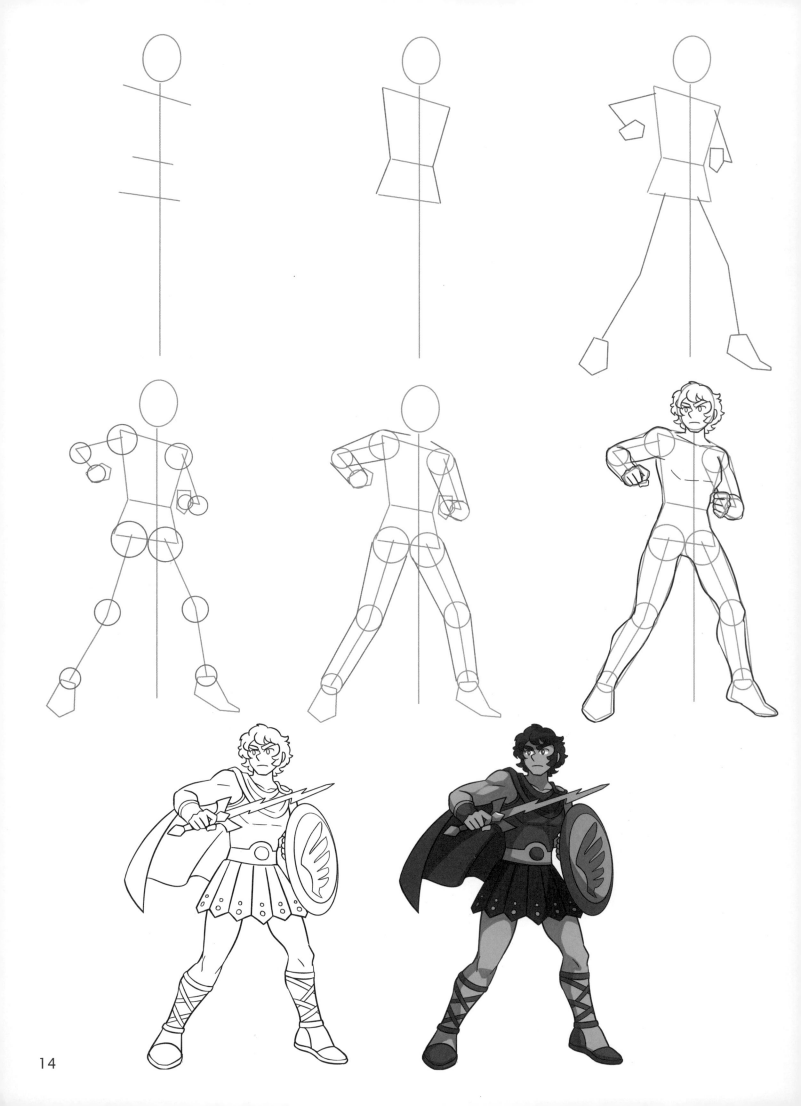

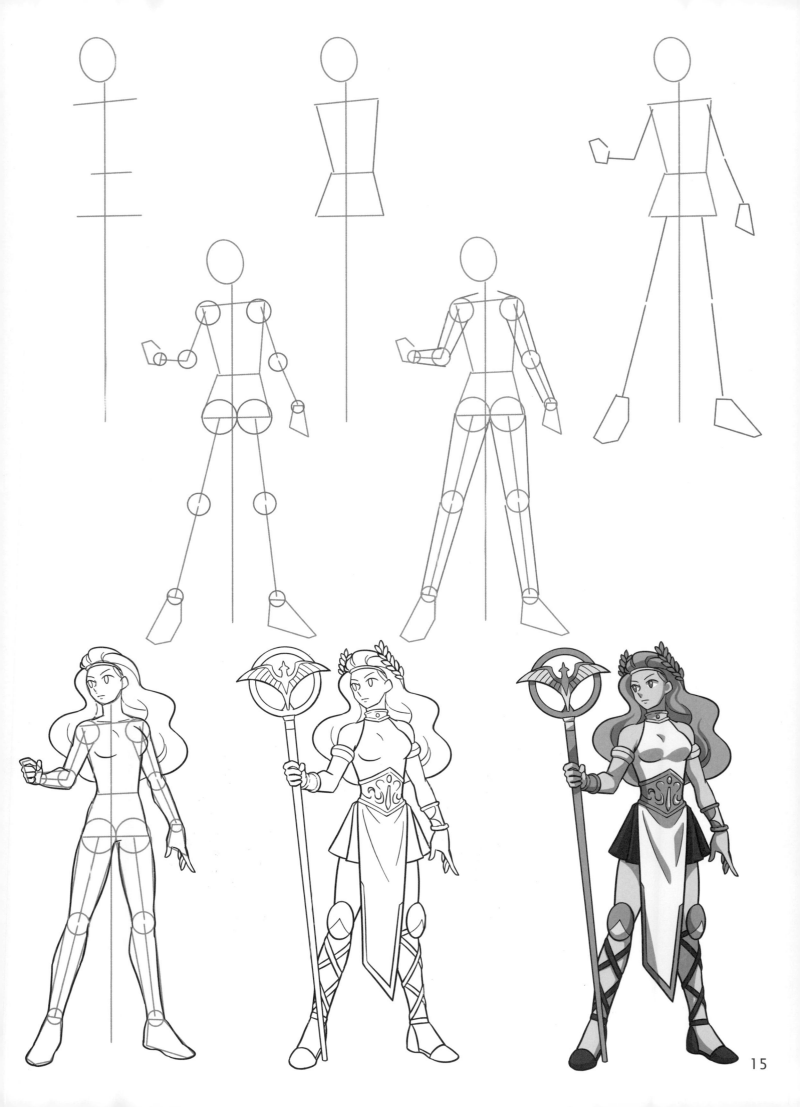

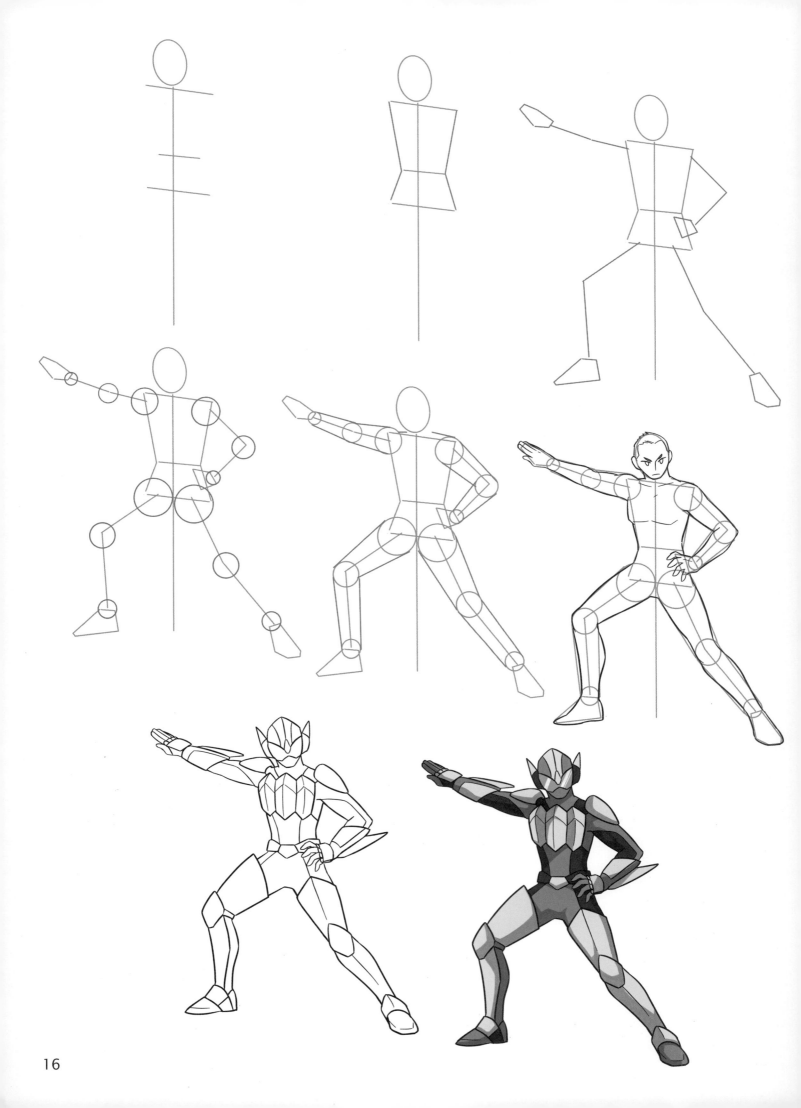

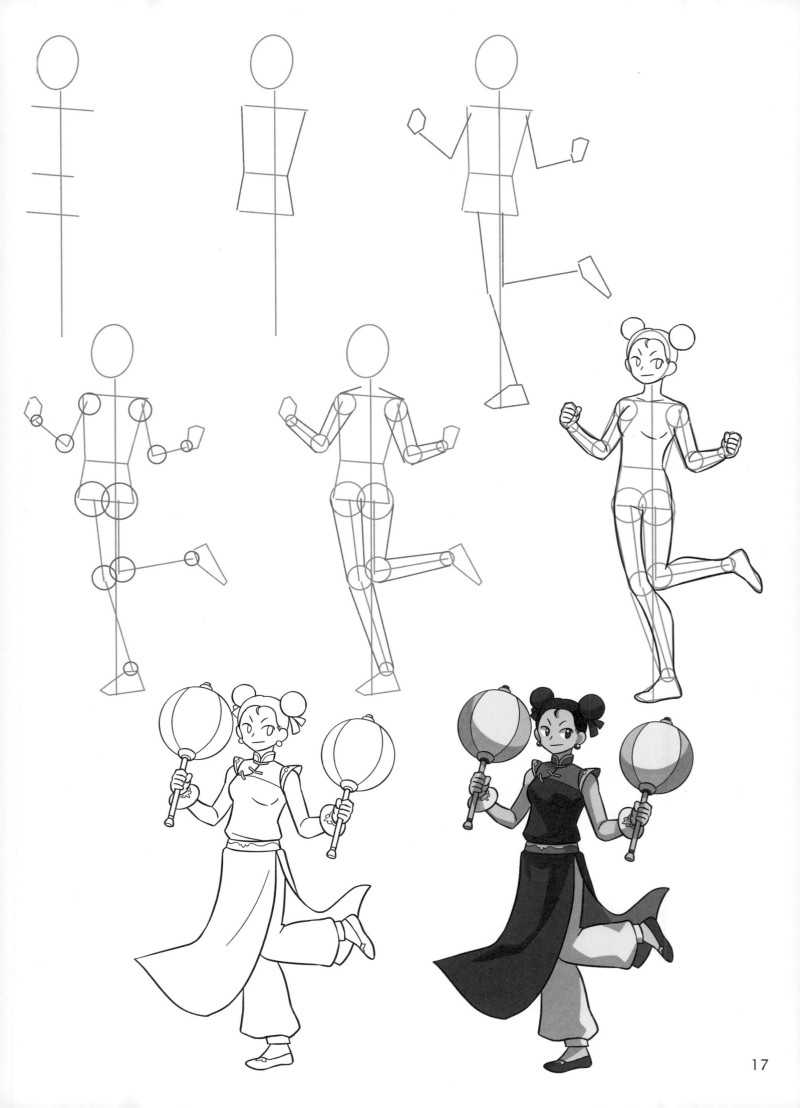

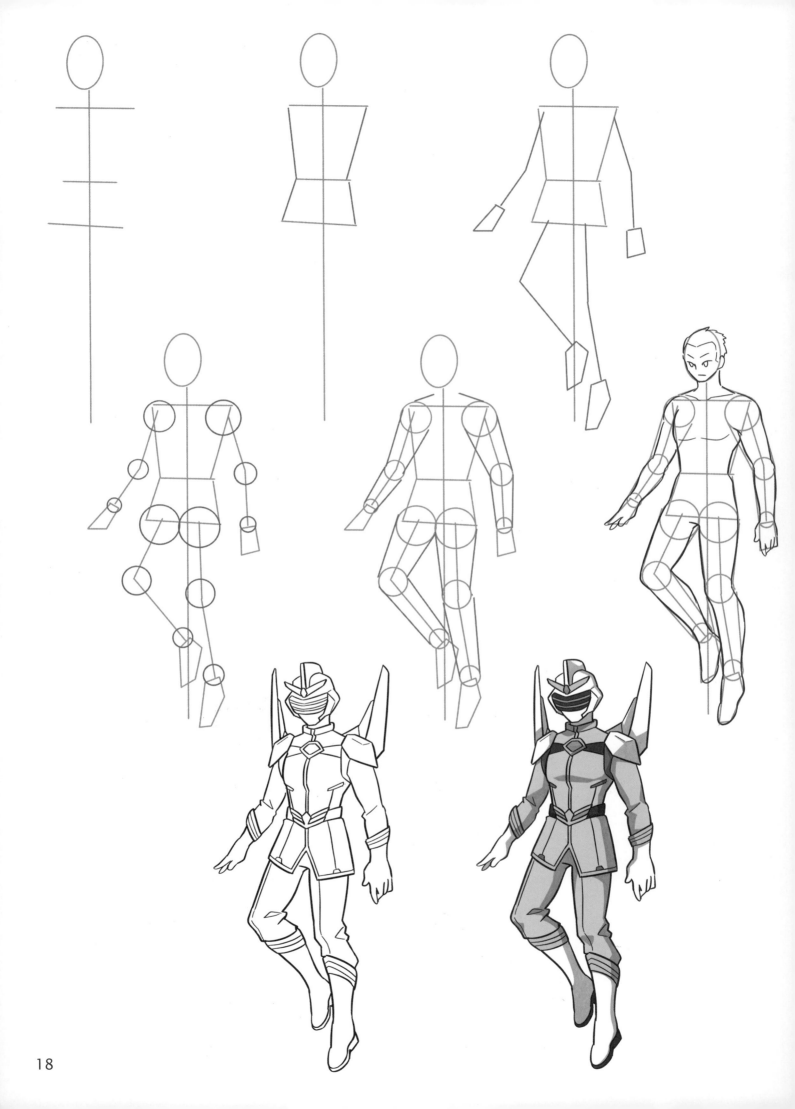

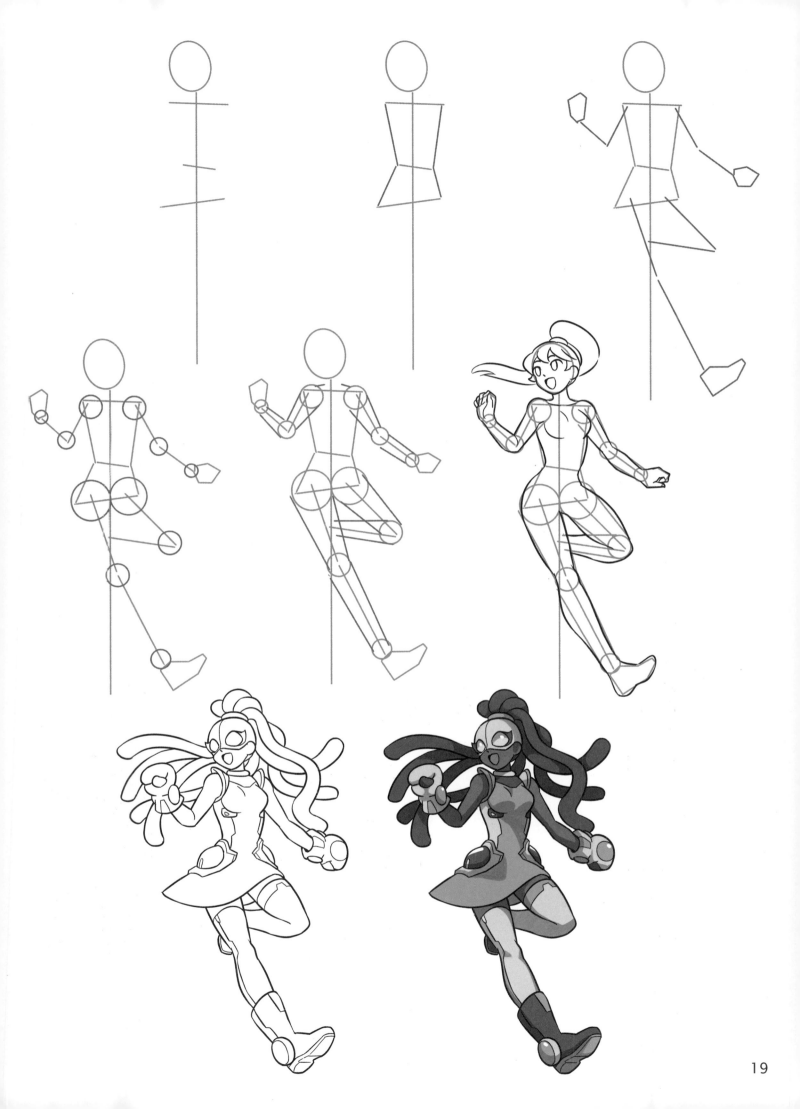

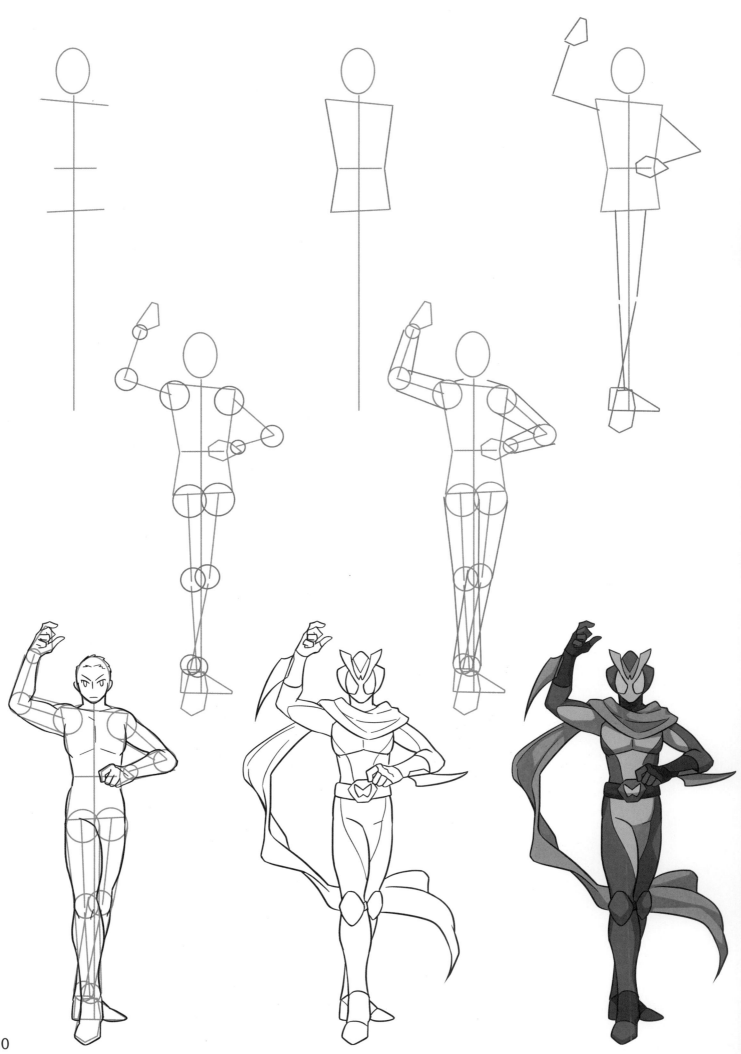

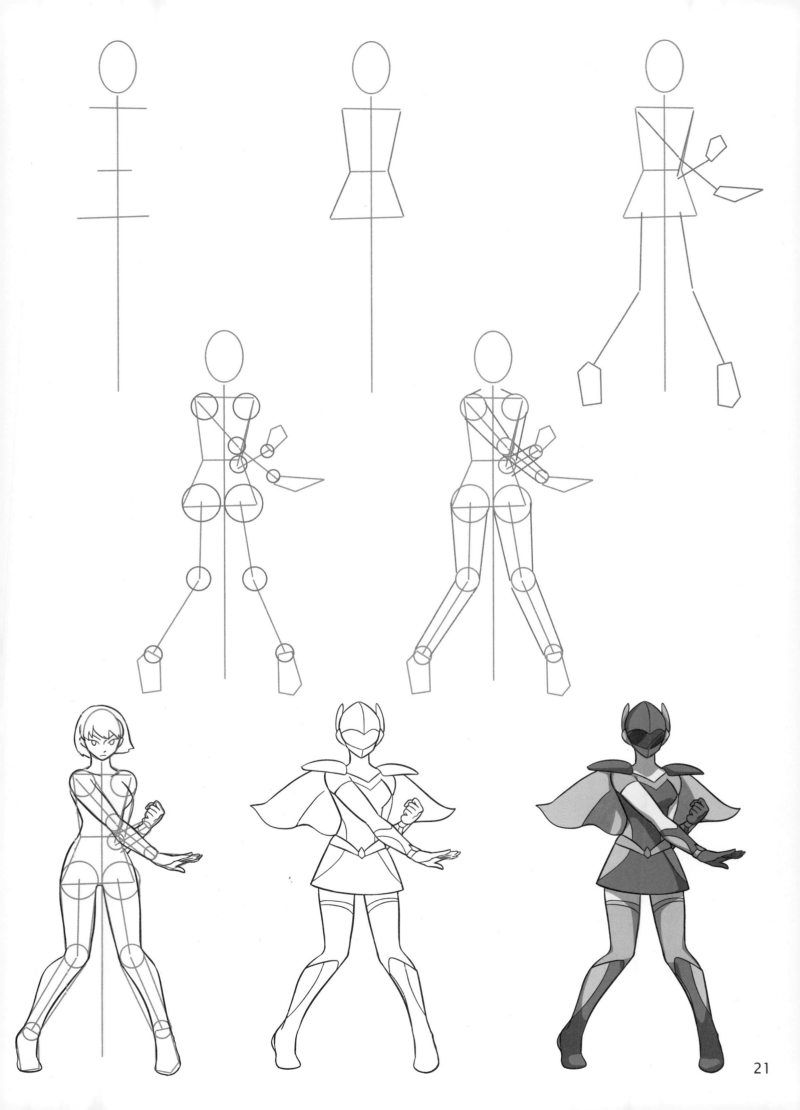

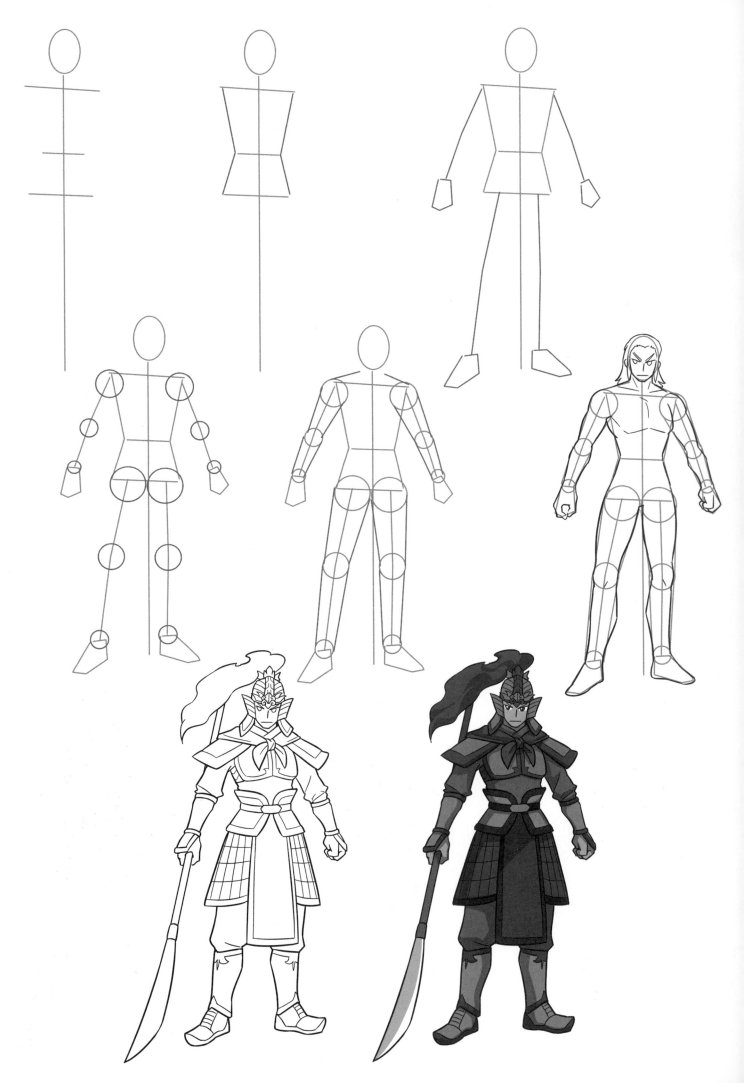

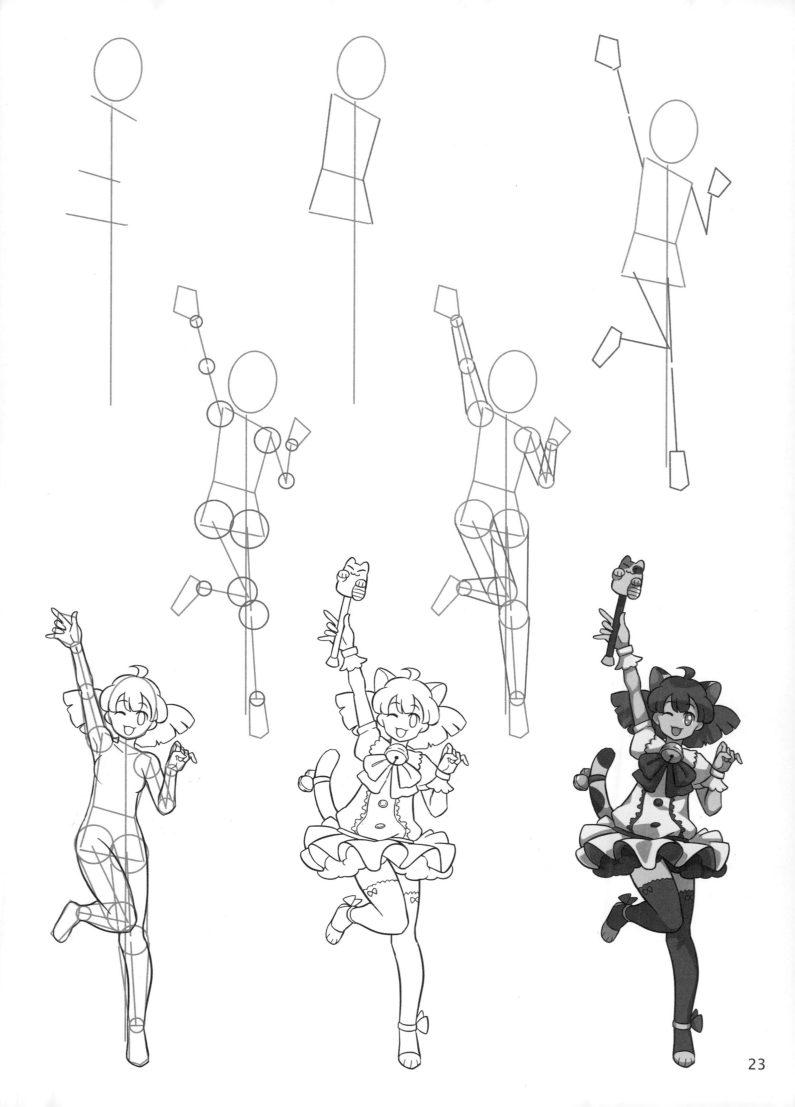

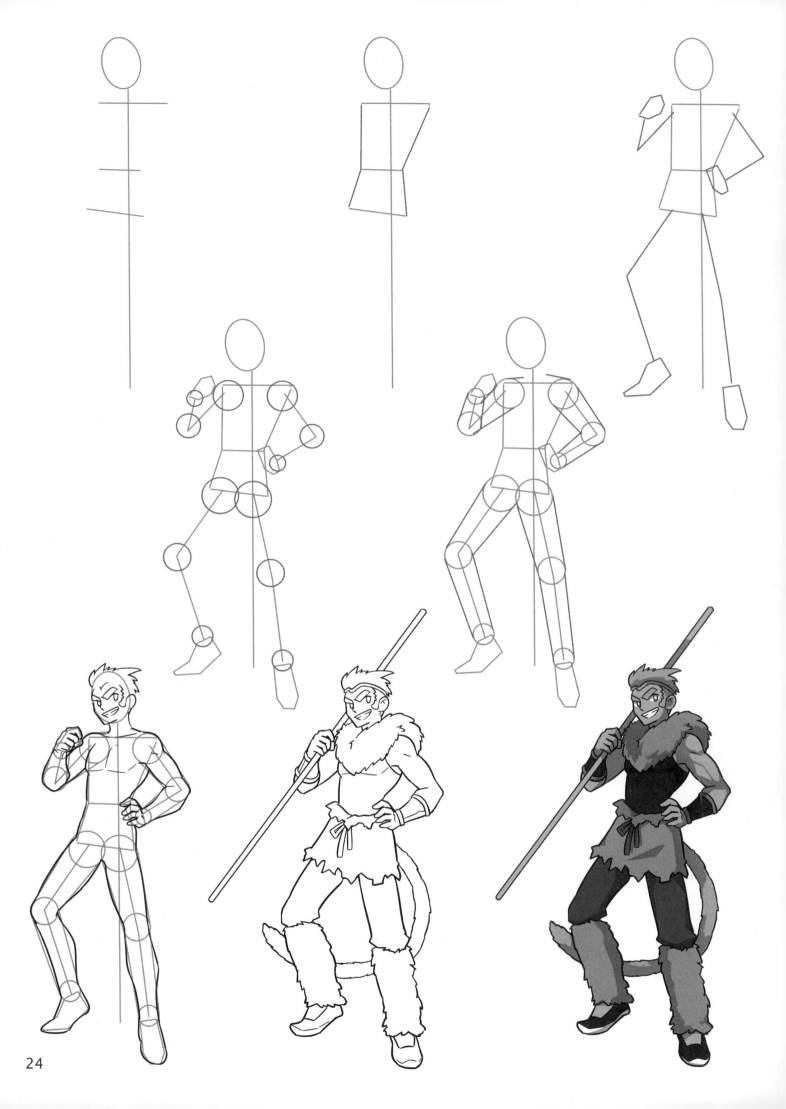

24

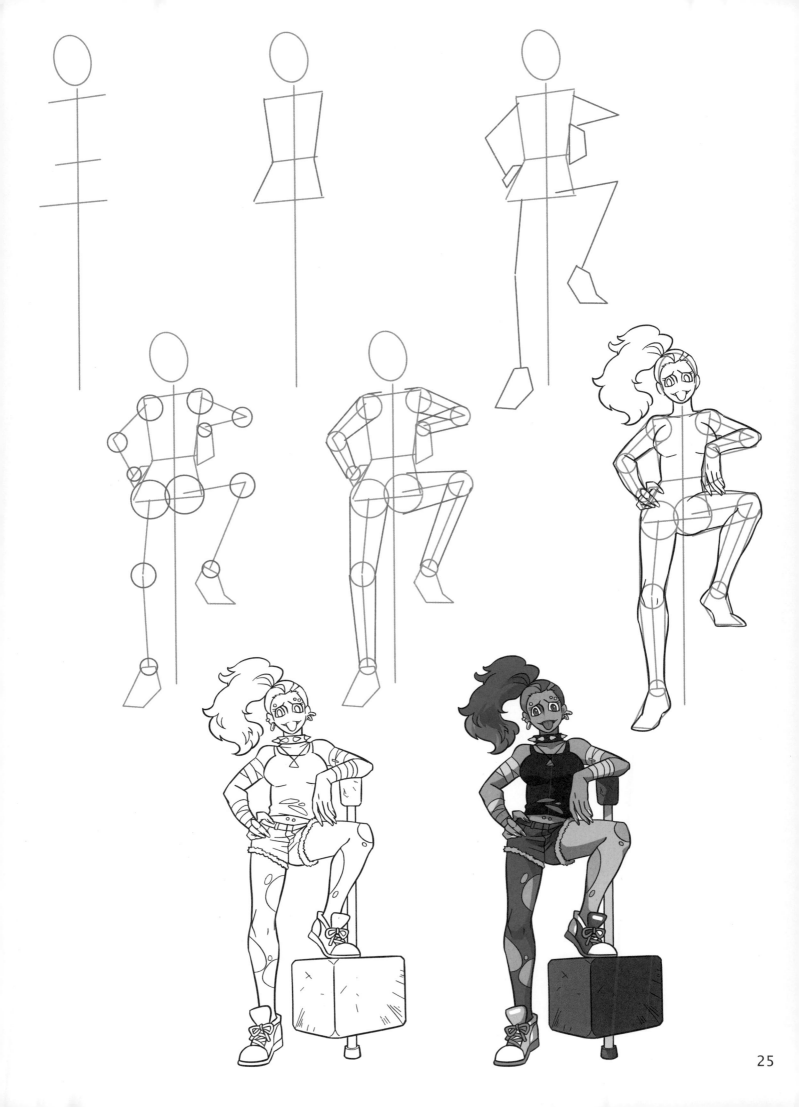

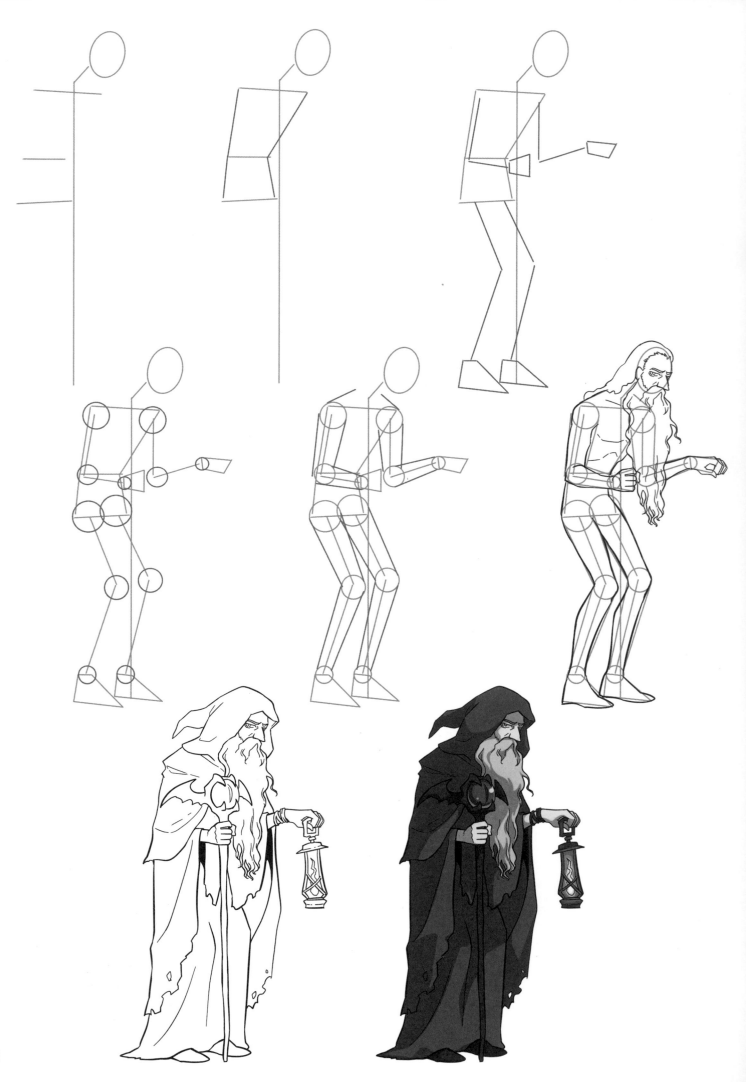

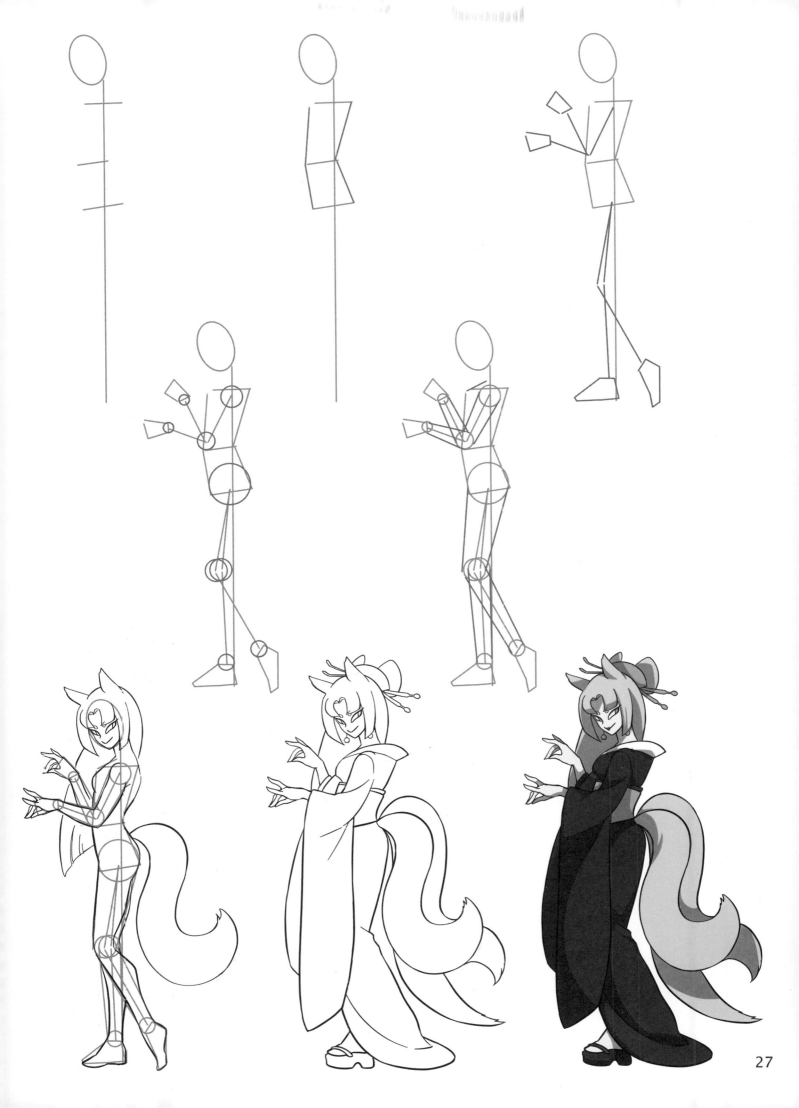

27

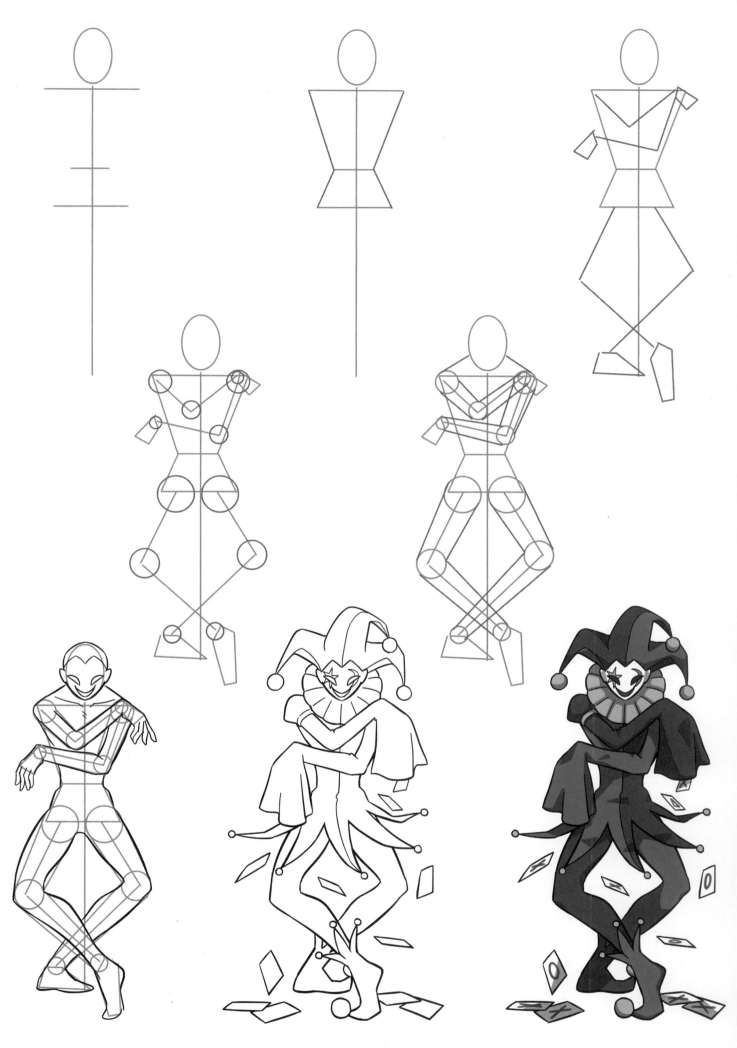

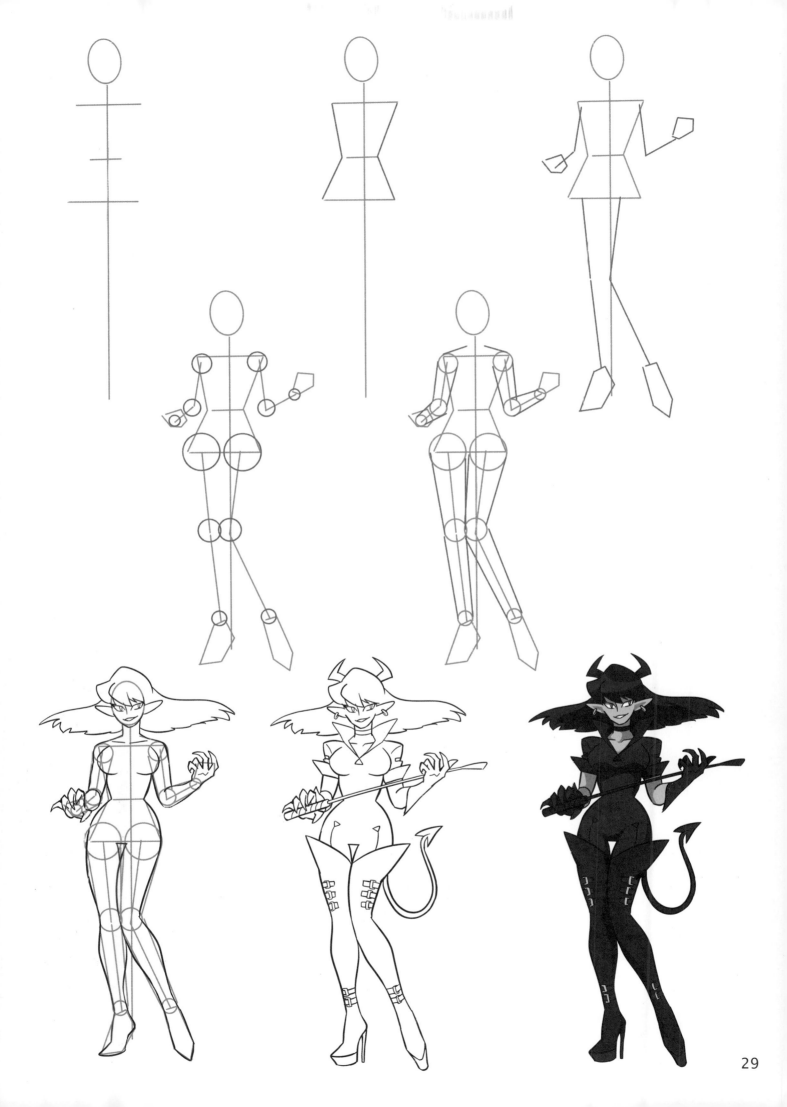

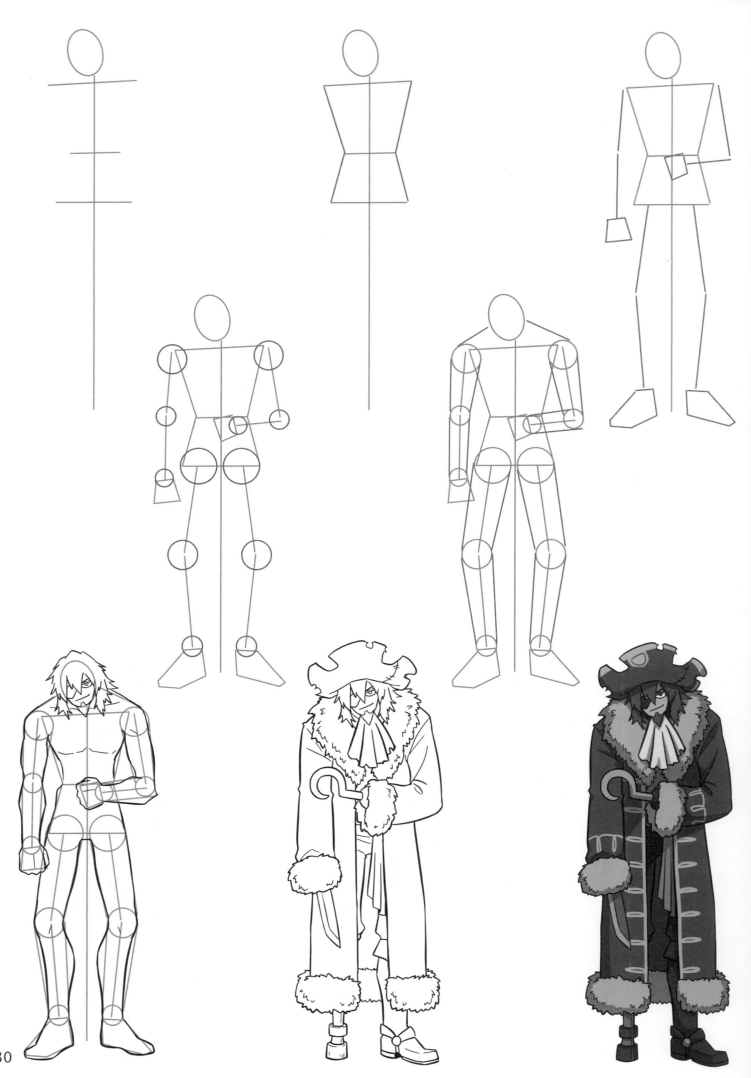

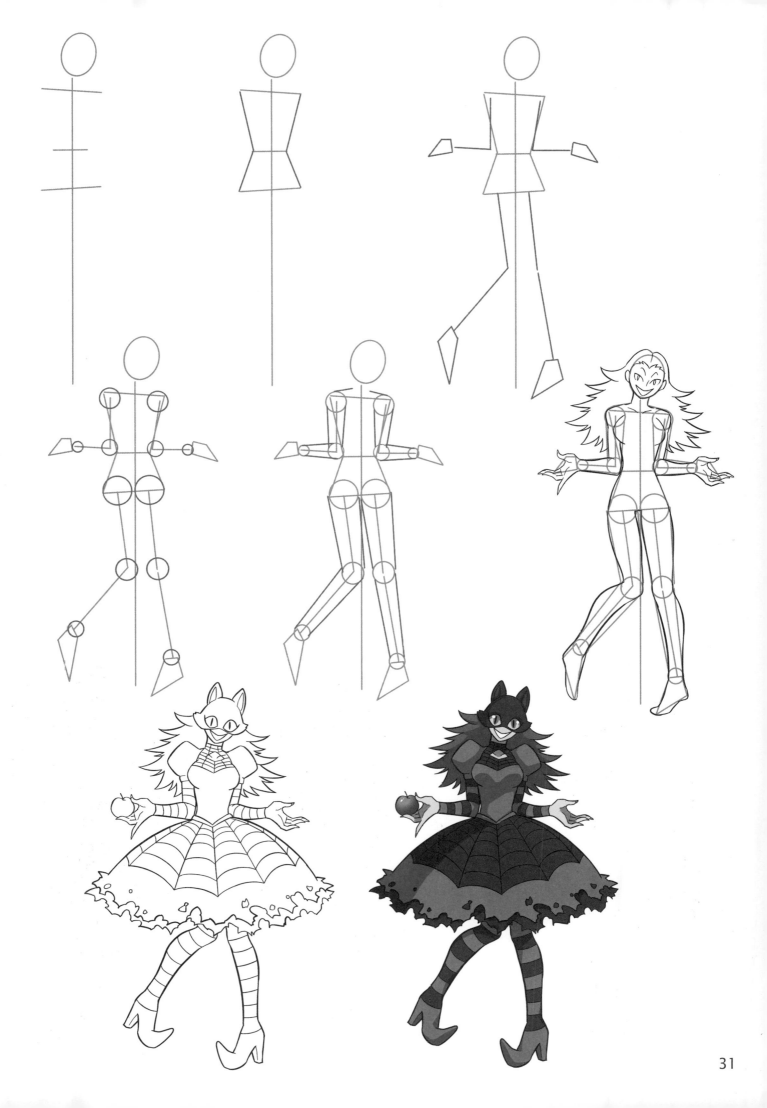

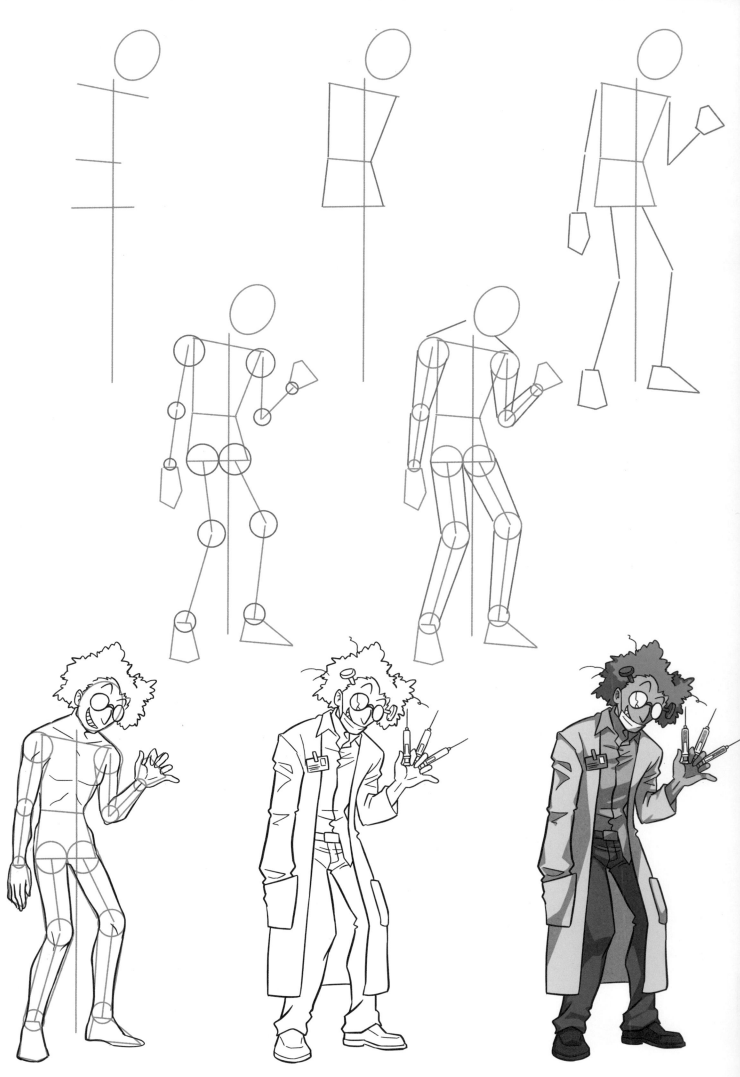